Kirsten Burke's Secrets of Modern Calligraphy

You CAN do it!

Using a nib can seem a little daunting, so I've broken this book down into seven simple projects. Each one teaches you a secret to help you create a piece of work so gorgeous, you'll be dying to start working on the next one.

By the end of the book, you'll have worked through all you need to know to create your own modern calligraphy with confidence.

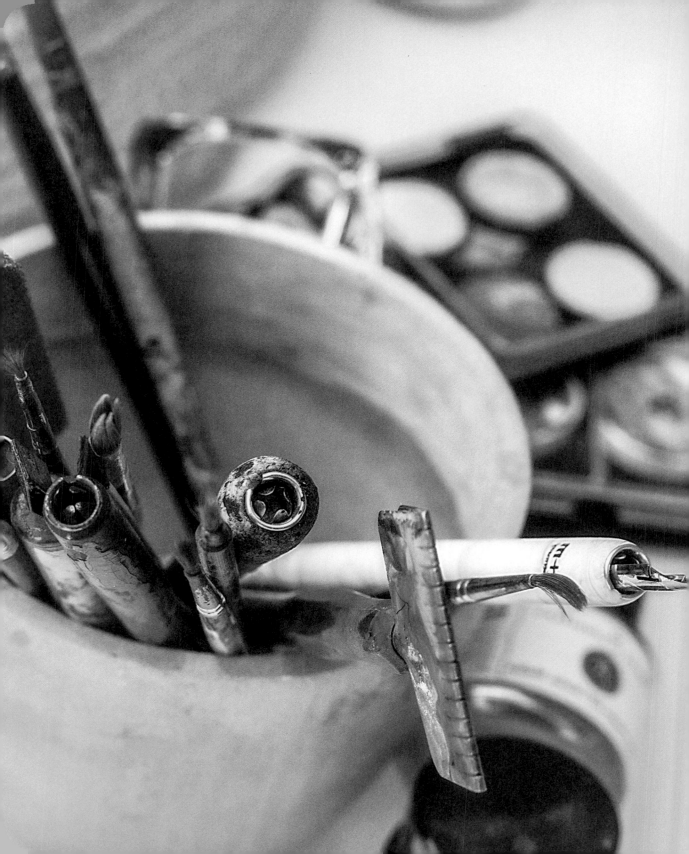

Contents

THE SECRETS

Each project reveals more of the secrets of modern calligraphy, so that by the end of the book you will be armed with everything you need to continue on your own lettering adventure.

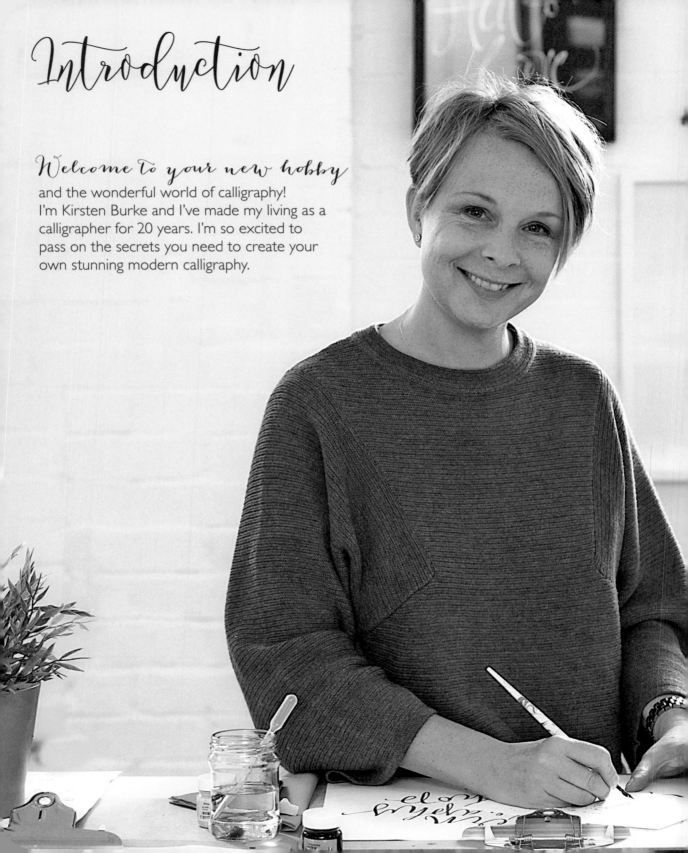

Introduction

Welcome to your new hobby

and the wonderful world of calligraphy! I'm Kirsten Burke and I've made my living as a calligrapher for 20 years. I'm so excited to pass on the secrets you need to create your own stunning modern calligraphy.

Calligraphy is relaxing.

You get so absorbed in what you're doing, that you forget about everything else – we all need a little bit of 'Me' time.

Is your handwriting terrible? It doesn't matter. You aren't artistic? It doesn't matter. You can still get amazing results. The fun thing about modern calligraphy is that it doesn't need to be perfect; it's the imperfections that make it so human, and that's the appeal.

In this book, I'll take you through which supplies you need and how to hold and use your pen. As you work through the projects, your calligraphy will improve. When you finish, look back at your first page – you'll be amazed at how far you've come.

I want you to enjoy calligraphy right from the start, so instead of drills (where you repeat the same letter again and again), I've created simple templates. They teach you the same muscle memory, but are much more fun to do! I've used some of my favorite phrases and put them on the art cards in this book for you to pull out, complete and frame.

What makes it modern?

The key to modern calligraphy is that it's written with a pointed nib, rather than a broad edge nib. This means that the nib comes to a sharp point and you make thick and thin lines by pressing harder and softer as you go up and down. It is also called a 'dip pen', as you dip your pointed pen into ink. As the nib has a point, it can be used by anyone, right-handed or left-handed and because it's easy to use, it is great for kids too.

Traditional calligraphy that you see in ancient documents in museums was made with a broad edge nib (a nib with a wide, flat end instead of a point). This is held at a consistent angle to create the thick and thin strokes.

Modern calligraphy is about lettering that has energy, without worrying too much about traditional rules. The lettering you make needs to look balanced on the page, but you don't have to get a perfect letter that looks identical every time. Creating your own style and having fun is what it's all about.

How to Use this Book

Work straight into the book.

I know you don't want to spoil it, but this book has been designed that way. It also means that you can follow your progress. You can tear out the layout paper supplied at the back of the book, which is thin, semi-transparent paper. Use it to trace over things, so that you can practice the exercises as many times as you like.

1

Projects

This book contains seven projects, starting with the simple stuff and gradually revealing the secrets of calligraphy. Your confidence will grow as you complete the projects, plus you will have made your own calligraphy art, ready to pop in a frame. By the end of this book, you will be ready to get busy lettering on anything that doesn't move!

2

Tips and Tricks

In each project, I will guide you and take you through the different techniques, step by step. Each section has a corresponding pull-out art card at the back of the book for you to complete. Use the layout paper at the back of the book to practice each template again and again.

3

Templates

These are my secret weapon! Instead of writing single letters out again and again, I think it's much more fun working over a template (faint calligraphy) because when you finish, it will look absolutely amazing. You learn all the same things, gaining the muscle memory you need to go it alone, but you get rewards along the way.

Watch

Access **Kirsten Burke Calligraphy** video tutorials on our YouTube channel to see practical tips and advice to help you develop your skills and confidence. Whenever you see the symbol above, scan the QR code with your phone or tablet to see demonstrations and how-to videos. You'll need a QR code reader app, which is free to download.

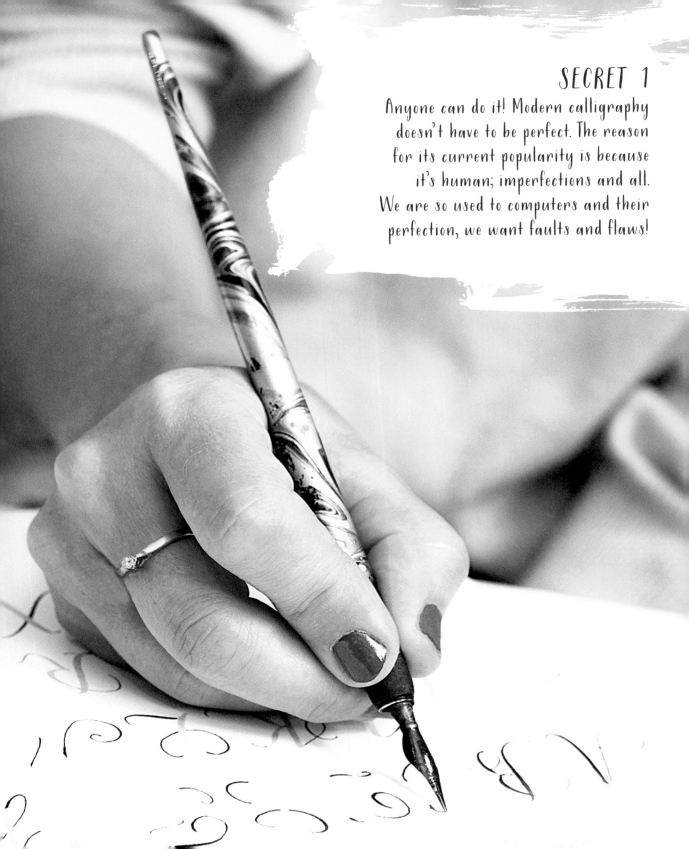

SECRET 1

Anyone can do it! Modern calligraphy doesn't have to be perfect. The reason for its current popularity is because it's human; imperfections and all. We are so used to computers and their perfection, we want faults and flaws!

Your Kit

SECRET 2

There is no such thing as the perfect nib.
Which nib you like best will be down to your own
personal preferences and will depend mostly on whether
you naturally press very hard when you write, or
whether you have a lighter touch. The size of the
tip also varies from nib to nib so you will
need an extra fine nib for very thin lines.

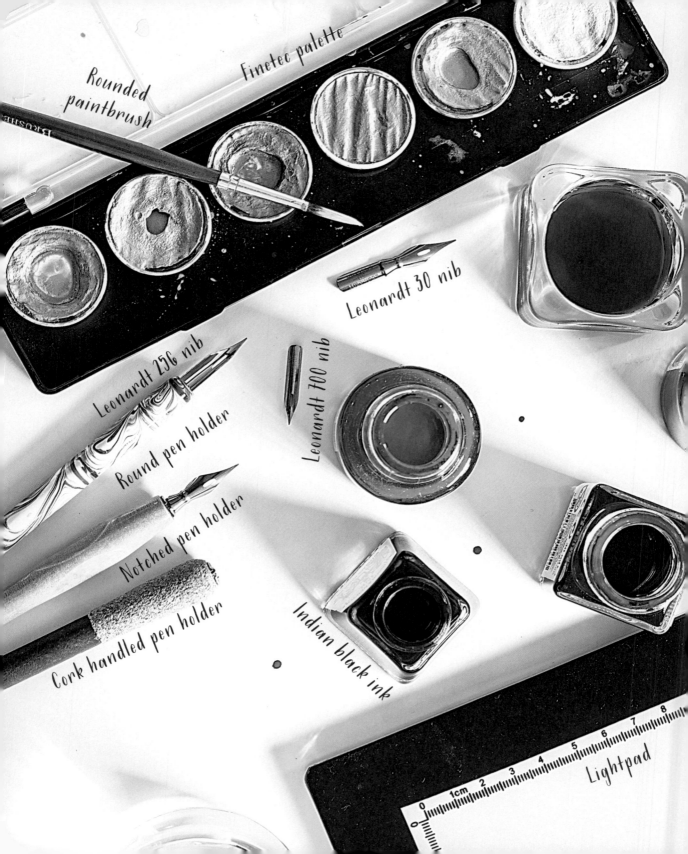

Rounded paintbrush

Finetec palette

Leonardt 30 nib

Leonardt 256 nib

Leonardt 700 nib

Round pen holder

Notched pen holder

Cork handled pen holder

Indian black ink

Lightpad

Shopping List

The great thing about calligraphy is that you can get started with very little equipment. All you need is a straight pen holder, a pointed nib and some ink. Later in the book, I will show you how to work in colored inks or metallics, so you may like to invest in those too. Everything else you need to get started is in this book, or you will have around your home already.

Essentials

Straight pen holder
Leonardt 30 pointed nib
Black ink
Plastic pipette
Small paintbrush

Optional

Other nibs
Coloured inks
Metallic palette
Pad of layout paper
Lightpad

From Home

A jar of water – to rinse your nib or dilute inks. Tap water works just fine.

A pencil – to sketch out your ideas in rough.

A lighter – to 'season' your nib.

A napkin – to wipe the ink off and for any spills.

A guard sheet – a piece of paper to put under your hand to stop your work getting dirty.

Nibs

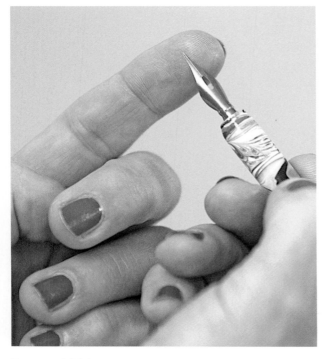

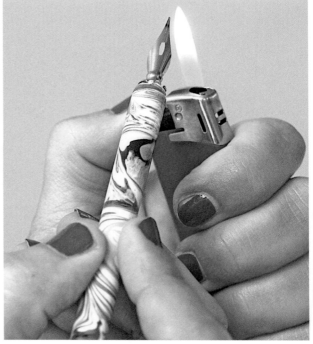

Pointed Nibs

There are many different pointed nibs available. In my experience, most beginners are worried to push down on their nib. Larger nibs are a good nib to begin with as they're robust while you get used to applying the correct amount of pressure.

Nibs have a glaze on them. It protects from rusting but also repels the ink, so you need to take it off. It's simple to do, just hold the nib over a flame for a second, as if you were sterilising a needle. This is called 'seasoning'.

If you dip the nib in the ink and then look at it, there should be no beading on it at all. The ink should be evenly spread over the nib.

My Choice of Nibs

I teach lots of workshops and have tested different nibs with my students.

Leonardt 30 – the most popular by far in my workshops. It flows nicely and is flexible enough to get the thick and thin lines that make calligraphy look so beautiful.
Leonardt 256 – a firmer nib, for those who use more pressure when they write.

For when you feel more confident:
Leonardt 700 – great for smaller calligraphy, it's a tiny nib, so gives beautiful fine lines. This nib needs a light touch.
Brause EF (stands for Extra Fine) – also creates stunning small calligraphy.

Pen Holder

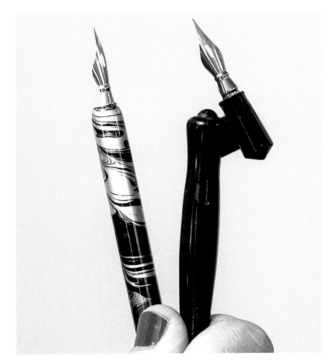

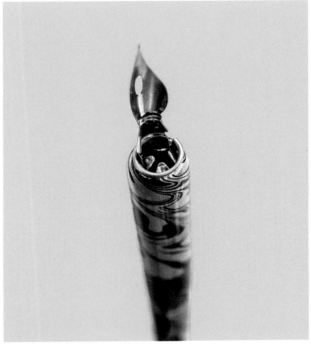

Types of Pen Holders
Straight – great for beginners and experts alike.
Oblique – the strange looking ones with the funny angled head. These are much trickier to use, so we don't work with them in this book.

My favorite type of pen holder is a straight, rounded one, but you can also get a cork end, which is great for your fingers because it's soft to grip; or ones that have grooves carved in them where your fingers sit.

Swapping your nib in and out of different pen holders causes it to wear out more quickly. Therefore, it's a good idea to buy a few pen holders so that you have one for each of your favorite nibs. That way the nibs will last longer. Whichever pen holder you buy, make sure it has a universal insert.

What is a Universal Insert?
Do you see the four metal 'petals' inside the rim on top of the pen? That's called a universal insert and accommodates most nibs. As nibs come in all shapes and sizes, that versatility is important. It may seem logical to put a nib in the middle of a universal insert, but you actually need to put your nib in just below the split, against the rim. Push in as far as the nib will go, so it feels secure.

This might seem tricky without seeing it in action, so I've made a video to help show you. Scan this QR code with your phone or tablet to watch the video.

YouTube
Kirsten Burke Calligraphy
Secrets-Nib

Ink

Paper

Black Ink
Let's start off with Winsor & Newton™ black Indian ink. It's great for beginners as the pot is small and perfect for dipping your pen into. Lots of calligraphers use Sumi ink, a dense Japanese ink, but it can get sticky on your nib and might not be suited to a beginner.

If you would prefer to use Sumi, buy a large bottle and pour some into a tealight holder. They make great dip pots.

Colored Inks and Paint
There are some lovely inks available now that calligraphy and brush lettering have become so popular. Winsor & Newton™ produce a range of calligraphy inks that have deep color and flow well. Ecoline are more transparent and come in a selection of gorgeous tones.

An alternative is to use watercolor paint. Although you can't dip into it, you can mix any color of the rainbow. The paint flows beautifully and you apply it to the back of your nib using a brush.

Finetec Metallic Paints
Before these metallic paints came on the market, writing in gold inks or paint could often result in the color separating, leaving you with ugly green where you wanted shiny gold. The Finetec paints never do this, they glisten while you write with them and they look stunning once they have dried.

You won't be able to work on just any type of paper, as the ink can feather and bleed, which makes even the most stunning lettering look scruffy. The key is to use paper with tight fibers, and the smoother the paper the better. Good quality laser paper is the best basic paper to practice on. When you are ready to create your own masterpieces try smooth watercolour paper or Bristol board.

Layout paper is a thin, semi-transparent paper that's great for tracing. You can't use normal tracing paper as it's shiny, so the ink isn't absorbed and will smudge. You can buy a pad of layout paper from any high street or online stationer which means you can trace over our templates and use them again and again to practice with. We've included some sheets to get you started at the back of this book. Use them when you want to trace over something like my alphabets or the pull-out art cards.

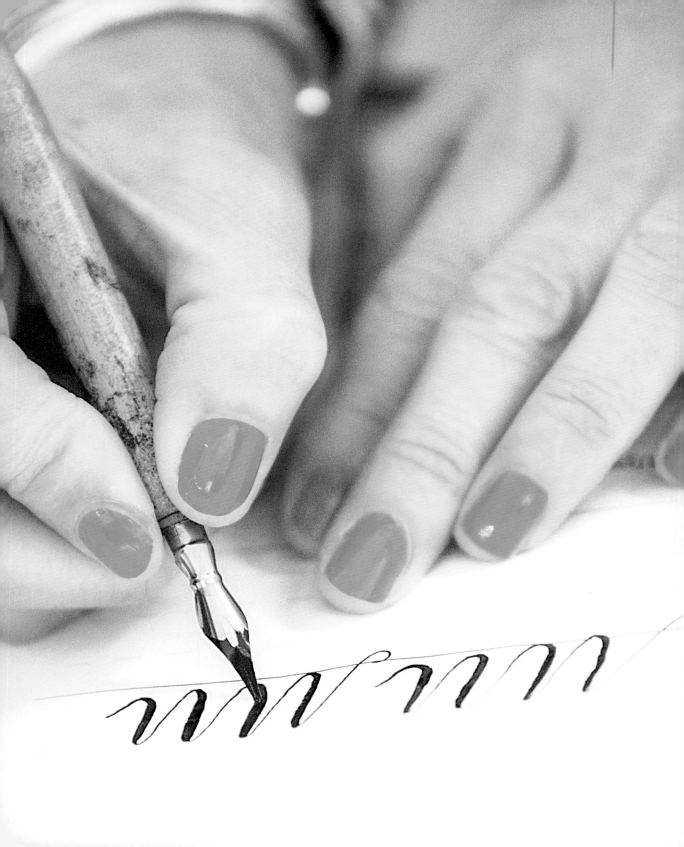

Getting Started

SECRET 3

It's all about the downstroke.
Focus on those thicks! Make them as thick as you
can. It's the contrast of the thick and thin line that
transforms normal lettering into calligraphy.
Do this and no matter what your style, your
lettering will be transformed.

Position

Body Position

You need to sit up straight, relax your shoulders and rest the palm of your hand gently on the table so that your arm can move easily back and forth. As you're working through the book and you get to the bottom of a page, move the book up rather than starting to scrunch up with your hand under your shoulder, and don't forget to breathe.

Holding the Pen

Hold the pen gently, it needs to feel comfortable and not hurt. Check the angle of the pen to the paper, make sure it's not too upright as you will get wobbly thin strokes, and could have issues with ink flow and the nib catching on the paper. Hold it about 30 degrees from the paper and make sure the pen holder, nib and your arm are all pointing in the same direction.

Ink Position

You are going to be doing a lot of dipping, so make sure you put the ink pot on the right, near your hand if you're right-handed and definitely not at the top of the page in case you drip any ink on your paper. Put it on the left if you're left-handed. This may sound obvious but it makes dipping much easier and quicker.

By turning your paper you are getting the same angle as is made by using an oblique pen – the one with the funny angled head!

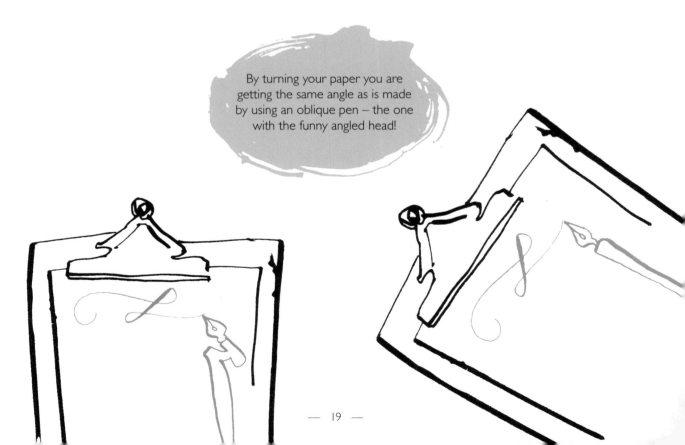

Paper Position

Sit at your desk with your work straight in front of you. Now turn your paper 40 degrees counter-clockwise (clockwise for lefties). The pointed nib was designed for Copperplate calligraphy, a beautiful, flourishy antique writing style.

If you imagine that Copperplate scribes used an oblique pen holder rather than a straight one, then you can see that by moving our paper, we mimic this position. See diagram on page 19.

When you do a simple up- and downstroke, the lines that you make are also pointing in the same direction as your paper, hand and arm.

If the ink isn't flowing well, tweak the angle of the paper slightly (by twisting the page a little to the right or left) and try

another downstroke until it does flow.

Thick strokes are produced when you apply pressure which opens the nib. That's why the position of your nib is so important, the tines (see overleaf) MUST be able to open up when you apply pressure. Fine, thin hairlines are produced when the pointed nib is lightly touching the paper and no pressure is applied to the nib. Keep a loose grip and incorporate your wrist and arm into your writing.

YouTube
Kirsten Burke Calligraphy
Secrets-Position

Left-Handers

Pointed nibs are symmetrical, so it doesn't matter at all if you are left-handed. What does matter is whether you are an 'overwriter' or an 'underwriter'. If you're a leftie, you'll know what this means!

If you are an underwriter, as shown in the first picture, and keep your wrist straight when you write you will be able to work in the same way as a right-hander. The only difference is that you will need to turn the page clockwise, so that the pen will be in the correct position, as shown in the picture below.

If you are an overwriter and bend your wrist over the paper, as shown in the second picture, you will have to reverse everything, so wherever I talk about thick downstrokes, you will be doing thick upstrokes.

Start at the bottom of the letter and push the pen up, applying pressure on the nib to create a thick stroke. Go lightly on your downward strokes for the 'thins'. You will have to experiment moving your paper around, trying different nibs and finding a comfortable position so that the tines can open and the pen will work well for you. If your grip allows you to exert even pressure on both tines of your nib, then you are holding the pen correctly.

Underwriter

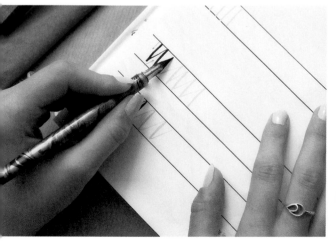

Overwriter

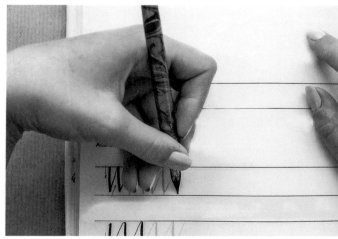

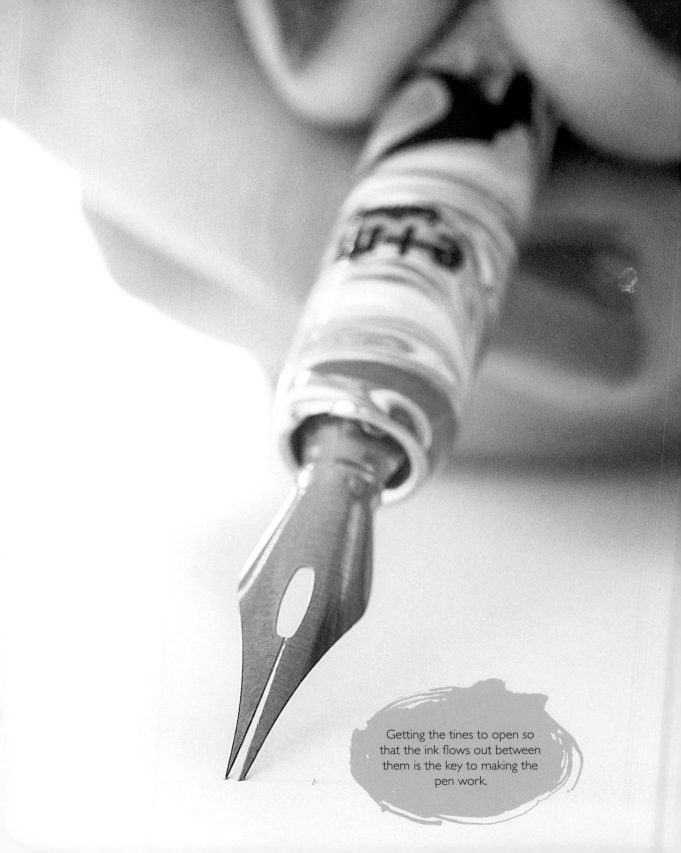

Getting the tines to open so that the ink flows out between them is the key to making the pen work.

Tines

Your pointed nib is made up of two split pieces of metal which fit perfectly together. These are called the 'tines'. The tines lead to a small hole called a 'vent', which holds the ink.

The tines must open up as you write to allow the ink or paint to flow out. If you place the tip of your nib flat on the paper and apply some pressure, you will see them open up as in the photo opposite.

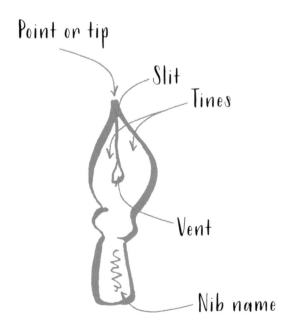

The name of a nib is embossed on it. You might need a magnifying glass to read it though.

Downstrokes
Pulling your pen down the page forces the tines to spread open, giving you a thick stroke. The more pressure you apply, the thicker the stroke. But be careful, too much pressure may make the nib snap.

Upstrokes
Pushing the pen up the page is a bit trickier. The nib can easily catch on the fibers in the paper, so go lightly! You need to apply as little pressure as possible without losing ink flow.

Cross Strokes
Your cross strokes are the horizontal lines, on a 'f' or a 't' for example. A gentle touch is needed as the nib will separate very slightly, giving you a thin line. It should be a little thicker than an upstroke.

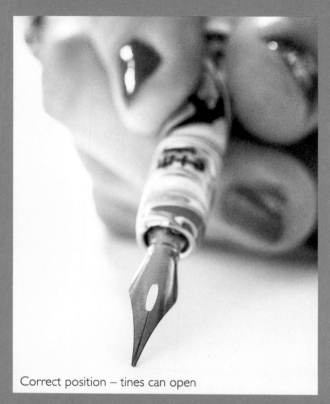

Correct position – tines can open

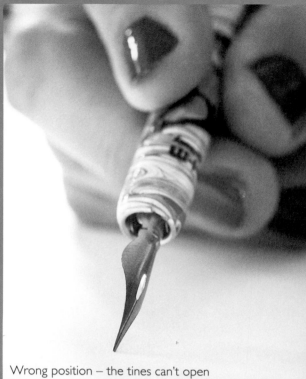

Wrong position – the tines can't open

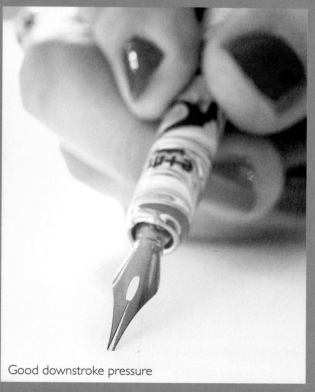

Good downstroke pressure

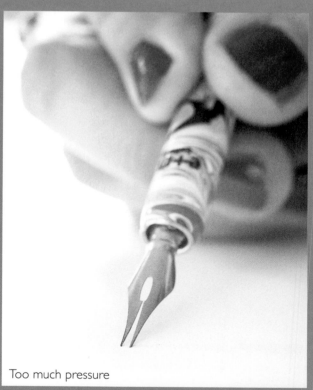

Too much pressure

How Hard to Press

Grab Your Pen
Before you even dip into the ink, let's check your pen is in the right position to work for you. Trace over the marks and look closely at the tines of the nib.

Thick Downstrokes
The tines should splay out to the width of the white line when there is ink in your pen. Those tines opening up and depositing ink from between them is how the thick line is made.

Thin Upstrokes
Going up is all about keeping the tines closed so that you don't catch on the paper, and you get a beautifully thin line. It will feel scratchy to start with. This is normal, so go gently. Loosening your grip on the pen holder helps. Try making the delicate upstroke again without using any ink so that you can see how it feels.

Let's Get Inky!
OK, we are ready to try some calligraphy. Season your nib, grab your ink pot and let's go!

Look at the vent, the small hole in your nib. Dip your pen into the ink so that the vent is filled with a little ink, then dab off any excess by gently touching the nib on the side of your ink pot. Don't dip it in so deep that the pen holder is submerged, as getting liquid, ink or water in the pen holder will cause the metal 'petals' to rust. Use the ink level guide below to help you.

How Often Should I Dip?
This varies from person to person, but you will quickly get the hang of it, so don't worry. To start with you may use too much ink and get some blobs, or too little and run out on the first letter, but after the first few strokes you'll start to get the hang of it.

Ink Level

— 25 —

Faux Calligraphy

This is a way of getting writing to look like calligraphy, without doing any calligraphy! Write a word in pencil then add lines parallel to the downstrokes following the original line closely. You are thickening up the downstrokes by hand, which is exactly what the dip pen does in real calligraphy. Once you color in the spaces, you have an effect that resembles calligraphy, but boy is it time consuming! Picking up your dip pen and using the pressure to get the tines to open is so much easier.

I mention 'faux' calligraphy because it is a great way to clearly show where those thick downstrokes go. When the Victorians looked at the manuscripts that medieval monks had written, they thought the thick and thins of the lettering were made in this way, and they would copy it by coloring in, just as faux calligraphers are doing now.

Have a go on the next page.

1 abcd

2 abcd

3 abcd

4 abcd

Write your name in your own handwriting in pencil, then go through the steps, turning your handwriting into faux calligraphy. This takes a little time!

Again, write your name in your own handwriting in pencil. Now go over it with your dip pen, putting pressure on every downstroke and keeping every upstroke light and thin. See how much quicker it is with a nib!

Let's Get Inky!

Downstrokes

Put pressure on the downstroke to create the thick line. Start at the top and pull down so the pen's tines open up. As you drag your pen downwards, the ink should release. If it won't flow, wiggle the nib on the spot and try again.

Trace over the gray lines here and then try freehand.

The star shows your starting point. ☆

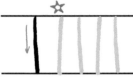

Upstrokes

For the upstroke, loosen your grip. This will help to reduce the pressure you put on your nib. Glide upwards gently. Trace over the gray and then try freehand.

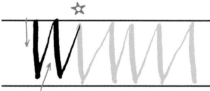

Watch how your pressure changes. Now add a slight curve where you switch strokes.

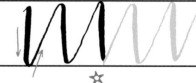

Tip

By working into this book you have a record of how much you've improved. I'll remind you at the end to look back at this page. I think you'll be impressed at how far your calligraphy has come.

Downstroke

Put pressure on the downstroke to create the thick line. Start at the top and pull down so the pen's tines open up.

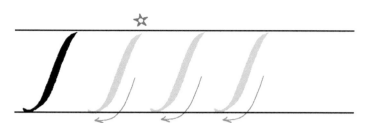

Sit up straight, near the edge of your chair. Hold the pen straight out in front of you with a relaxed grip on the pen.

Upstroke

For the upstroke, loosen your grip. This will help to reduce the pressure you put on your nib. Glide upwards gently.

Cross Stroke

For the cross stroke, like the cross bar of a 't', loosen your grip, as you would with an upstroke and go gently (lefties may prefer to go the opposite way here).

Combine the down and upstrokes, to create the shape below. Go over the gray, following the direction of the arrows.

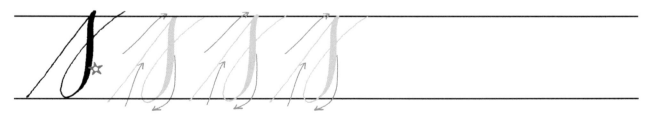

Tip
You can move the angle of your forearm and wrist, but the pen must stay at the same angle.

YouTube
Kirsten Burke Calligraphy
Secrets-Ink Flow

Shapes

Here are some shapes to get to grips with. Concentrate on getting the position of the thick stroke on the side of the letter shape. Don't let that thick line drop and hang at the bottom.

To make an oval or a circle start at the top, gradually apply pressure then release gradually by the bottom of the downstroke.

The star shows your starting point. ☆

Trace over the gray making the thick and thins in the same place.

Now have a go doing it freehand. It's much harder without the shape to follow, but it's great practice.

To join a letter to the next, use a thin upward stroke.

Practice Makes Perfect

Practice the shapes below, focusing on getting the downstroke nice and thick.

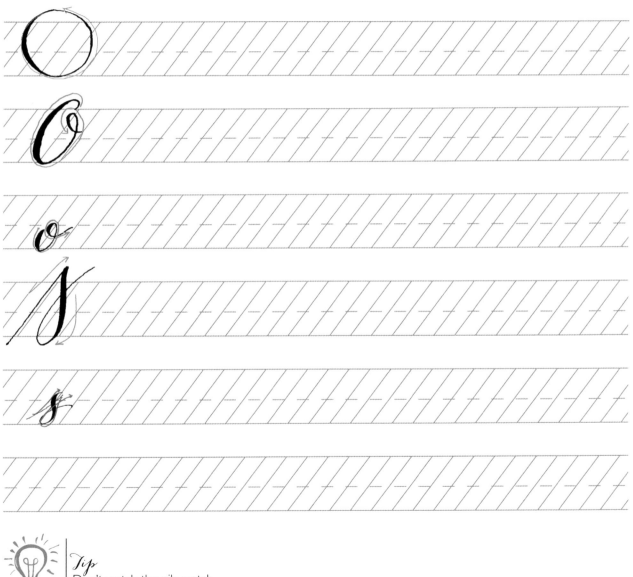

Practice Makes Perfect

Work on these guides to try different letter shapes.

Alphabets

SECRET 4

Don't forget to breathe!
Allow your forearm to glide over the desk
rather than leaning on it.
Just enjoy writing your alphabet,
getting the flow of the letters and your
thick and thin strokes in the right place.

Alphabets

Downstrokes

Well, here it is, your first alphabet! So have a look, a close look. See those big fat strokes? Those curly thin ones? It's that contrast of thickness that makes calligraphy look so lovely. When the tines are able to open and you add pressure on the downstroke, you'll get letters like these.

> With the downstrokes showing in bold, you can see clearly how the thick lines are like the backbone of the letter form.

a b c d e f g

h i j k l m n o

p q g r r s t u

v w x y z

Cursive Lower 'r'

Did you notice the decorative letter 'r' above? Calligraphers love to use this style 'r'. Its curly shape is great for keeping your lettering flowing. Where you begin and end a letter is called the 'entry' and 'exit' stroke, and this type of 'r' has a great entry and exit! Keep that little loop up higher than the cross stroke. You can always do a more conventional 'r' if you prefer it, it is just more jolty to write.

I have separated the thin and thick to really make it clear how each letter's form is made up of the thick and thin strokes you will be making.

A B C D E F G
H I J K L M
N O P Q R S T
U V W X Y Z

Upstrokes and Cross Strokes

Here are the upstrokes in bold. Notice how fine they are in comparison to the downstrokes. I've included the cross strokes here too, so you can see that these have some thickness to them. They need more pressure than the upstroke to get that weight, but not as much as the downstrokes.

The rule is the same for the small letters of the alphabet. The lower case is made in just the same way, with thick downstrokes, thin upstrokes and thin cross strokes.

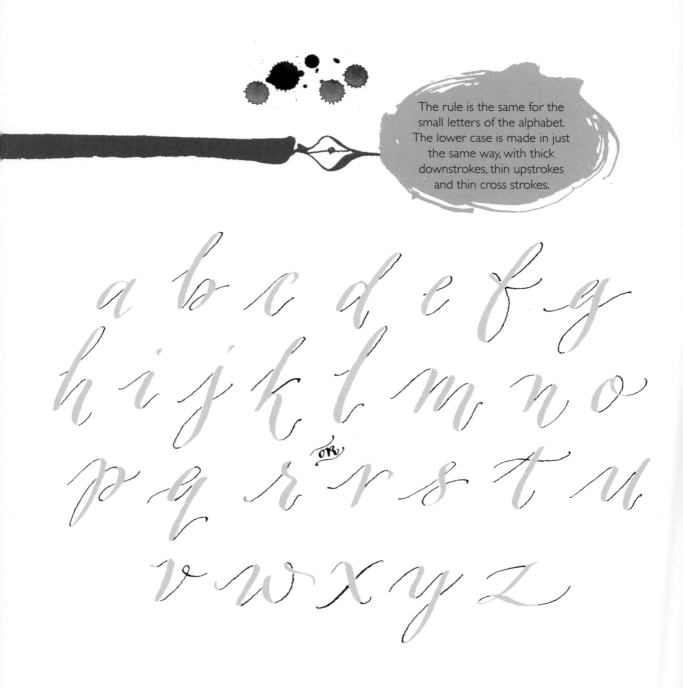

Your cross strokes, for cross bars and the tops of some capitals, need a bit of thickness to them. Turn your wrist so that you can do it, or you might need to shift your page slightly.

A B C D E F G

H I J K L M

N O P Q R S T

U V W X Y Z

Stroke Order – Capitals

So now it's your turn. Follow the arrows to see the order of the strokes and their direction. The thick strokes will be downstrokes, and thin will be upstrokes. Most cross strokes are thin, but I like a thick cross stroke for the 'L' and the 'T', so I move the angle of my page to make those cross strokes thick.

Write straight into this book tracing over the gray letters and following the order of the numbers. When you look back you will see how far you have progressed.

Notice how you come back up for the belly of the 'B' and 'D'. That's because they have thickness in that line too, so it needs to be a downstroke.

On the 'C', 'D', 'K' and 'T' the final stroke is just a flick to add that finishing touch.

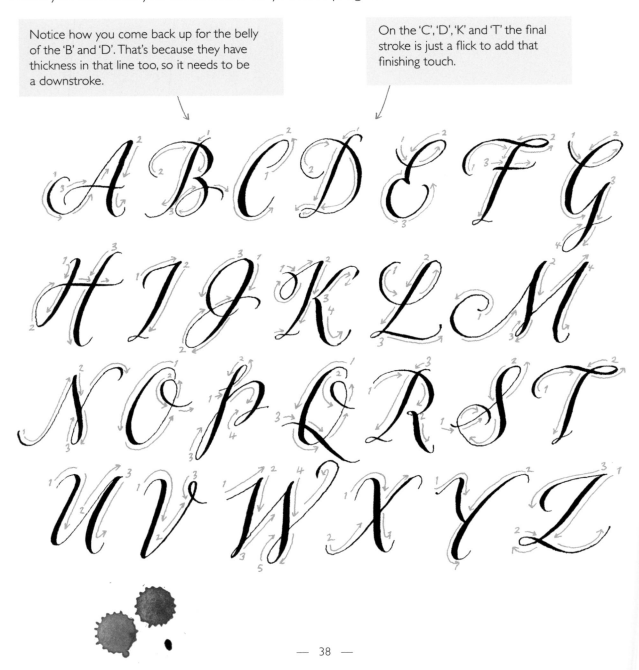

Tip
To get more practice, place layout paper over the alphabet and trace it as many times as you like.

Letters are made up of separate strokes, so it's ok to take your pen off the page for each one.

A B C D E F G

H I J K L M

N O P Q R S T

U V W X Y Z

Tip
If the ink won't come out of the pen give the nib a little wiggle on the spot that you're on and it will flow.

Stroke Order – Lower Case

So now on to the smaller letters. They may seem easier as the lines are shorter. Enjoy getting the feel of the pen and follow the arrows, but don't feel you are doing it wrong if you make a letter in a different order. It is getting the thick and thins in the right place that is important. Follow the numbers to see which order you should write your letters.

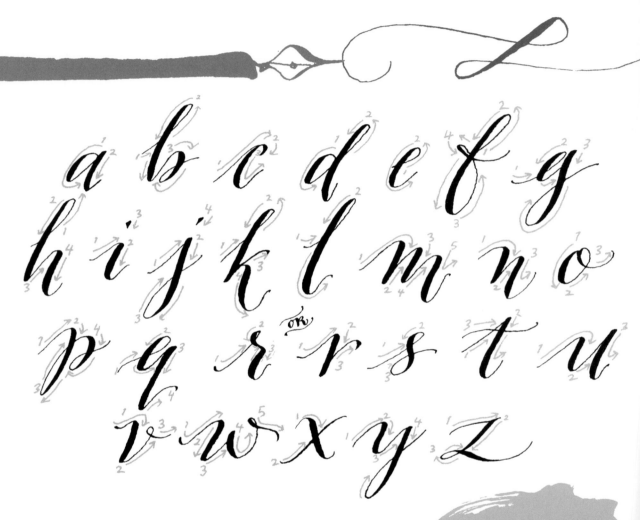

Tip
Does your pen feel scratchy, particularly on the upstrokes? Lighten your grip on the pen. Or you could be holding the pen too upright. Drop the pen holder to a 30 degree angle from the page.

Are you holding your breath? We often do when we are concentrating! Try and remember to relax, take deep breaths and keep your shoulders loose. This is supposed to be fun!

You should start to see an improvement from when you first started. Your calligraphy will be getting easier and less wobbly.

a b c d e f g
h i j k l m n o
p q r r s t u
v w x y z

Tip
If your downstrokes are not coming out thick, you may have twisted the pen so the tines can't open. Think of the pen as a skier coming down a slope. The skis need to stay flat and parallel as they glide over the snow. It's the same with the tines. Try making a downstroke without dipping in the ink so that you can check those tines are opening up.

— 41 —

Italic Modern

A B C D E F G

H I J K L M

N O P Q R S T

U V W X Y Z

a b c d e f g
h i j k l m n o
p q r or r s t u
v w x y z

1 2 3 4 5 6 7 8 9 0

Here are two of my alphabet
styles for you to use as a guide
to help you create your own
artworks.

Quirky Upright

A B C D E F G
H I J K L M N
O P Q R S T
U V W X Y Z

abcdefghi
jklmnopq
rstuvwxyz

1234567890

Here are another two of my alphabet styles for you to use as a guide to help you create your own artworks.

Letters into Words

SECRET 5

It's all about practice. Grab a little 'Me' time
all to yourself and start to practice the strokes.
Unlike when you learned cursive writing in school,
with calligraphy you can take your pen off the page
whenever you like, so take the nib away from the
page as often as you need and ponder your next
stroke. Don't worry if your upstrokes are a little
wobbly when you start. Be patient. With practice,
the more natural it becomes.

Project 1

Skills:
Proportion
Cursive letters

Modern calligraphy plays around with the rules of the traditional, so you need to know the rules before you adapt them to make your very own, unique style.

ASCENDERS are the upward 'branches' of the letters. They reach almost to this line. Capital letters reach this line too.

The X HEIGHT is the height of those letters that have no ascenders or descenders.

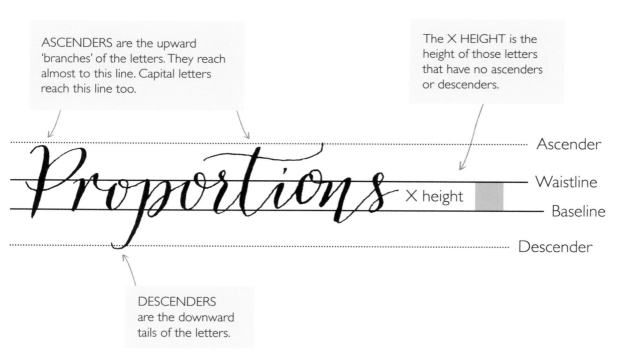

Ascender

Waistline

X height

Baseline

Descender

DESCENDERS are the downward tails of the letters.

In traditional calligraphy every letter would sit neatly on the baseline, and each letter would follow the rules. Modern calligraphy gives letters a chance to show off and dance around the guidelines. See how the word above uses the guides loosely? This is what gives it its contemporary style.

Don't abandon the rules altogether though, they will help with consistency and improve the look of your lettering.

YouTube
Kirsten Burke Calligraphy
Secrets-Thick and thins

You have lots of things to think about while you work – the pressure you put on the nib and keeping the ink flowing without dripping any ink on your page. That's why guidelines are a great help, they keep you on the straight and narrow. Modern calligraphy may dance, but you don't want your lettering to drift off either.

Trace over the gray letters below, noticing the guides and where the differently sized letters reach. Try some letters freehand at the end of the guidelines.

Ascender
Waistline
Baseline

Don't feel that you cannot take your pen off the page, even if your work is all cursive words. You are aiming for the impression of a continuous line, but dipping into your ink means you have to lift your pen away from time to time.

Try tracing over the alphabet below. The letters are all joined-up. Notice that your cursive stroke is always a thin, upward one. I have placed stars where I took my pen off the page to dip for ink. I try and get to the end of a stroke so that when I put the pen back down I am beginning the next stroke.

Don't be tempted to flick your pen on the upstroke. Calligraphy is about control and so even the thin lines need to be careful and deliberate for a crisp look.

Tip
You will feel the ink running out so try and get to the end of a stroke, then dip. That way your strokes will have flow. If the ink stops before you get to the end, dip and do your best to join where you stopped as smoothly as you can.

Cursive Letters

You want the effect to be that of a continuous flow. If you run out of ink halfway through a stroke, dip and go back to the beginning of that stroke to get the smoothest transition that you can. Trace over the gray words below and notice how the lettering moves your pen from the baseline to the waistline and back again.

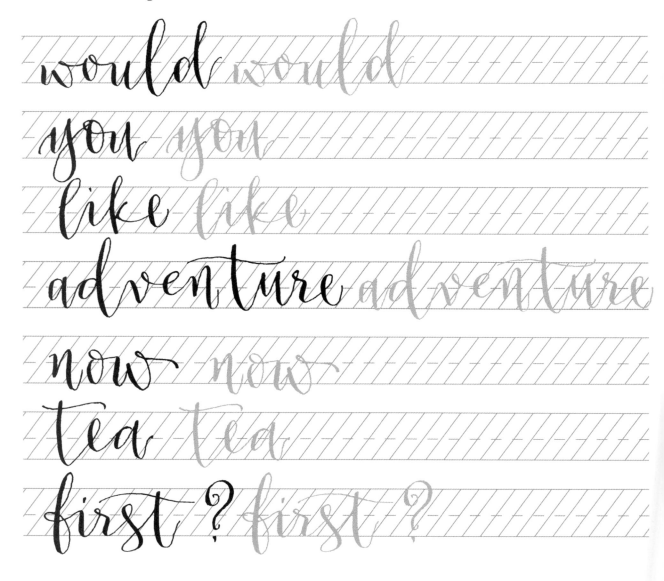

would would

you you

like like

adventure adventure

now now

tea tea

first? first?

Tip
Not sure you're holding the pen correctly?
The vent should be facing up. If your nib is turned
to the right or left the pen can't release the ink.

Once you have traced the word, try writing it again on your own, using only the guidelines. If you are worried about writing freehand, first sketch the words out gently in pencil and trace over them in ink. Your connecting strokes need a delicate touch.

Tip
"My letters have the thick stroke at the bottom not at the side!"
This is a very common complaint at the beginning. Check the angle of your paper and move it slightly. Try writing again and see if it's improved. The slightest change of paper angle can make all the difference.

— 53 —

Art Card 1

Designing pieces of calligraphy to decorate my home is my favorite thing to do. At the back of this book are seven art cards that I have designed especially for you to pull out and put on your wall for inspiration or to give to someone to brighten their day. Practice writing over the phrase below and when you feel ready, rework it straight on to the matching pull-out card (art card 1) at the back of the book.

would you like an adventure now or would you like your tea first?

ALICE IN WONDERLAND

Shapes

SECRET 6

It's all about time. You can't rush calligraphy. It's not the same as writing at all. Think of it as drawing. You need to go very slowly and deliberately. You are thinking about shapes and pressure with every single stroke, that's why it's so wonderfully absorbing. Your eyes are learning to see slight differences in the shapes you are drawing, and your hand is learning to improve drawing each letter shape too.

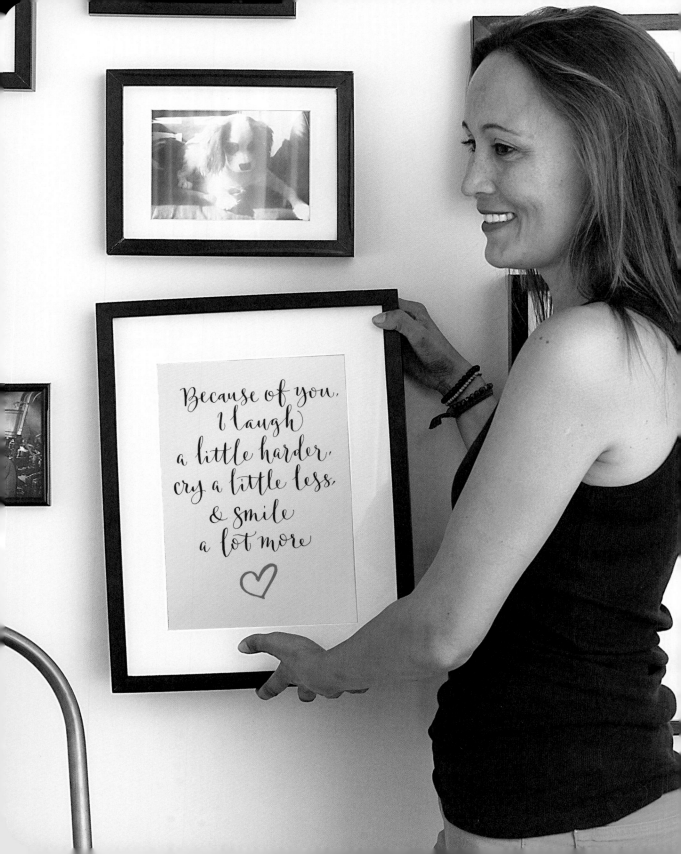

Project 2

Skills:
Body shape
Alphabet families

Time to talk about body shape... not yours, the letters'! Every alphabet has a family style. The letters within it have a relationship. The 'o' shape may be fat and round, or narrow and tilted, but whatever shape you choose, it should be passed on to the other letters. The other rounded letters in that alphabet now follow the 'o's lead. See how the rounded parts of an 'a', 'g', 'h', 'p' and 'y' all follow the same body shape. The proportion of the 'o' will also dictate the width of the other letters, even if they don't have an oval shape. See where I have placed the 'o' shape over the 'k'.

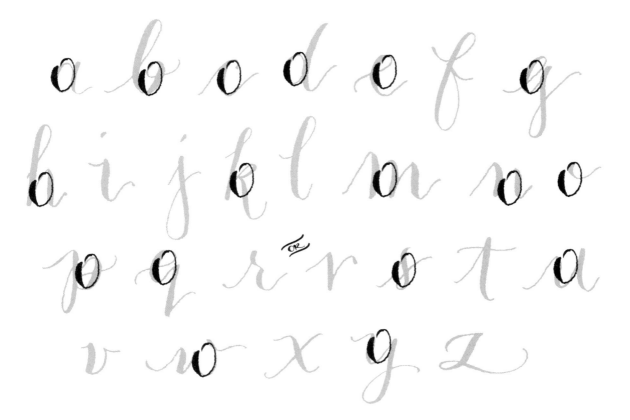

The 'o' shape governs all the letters, even the letters that don't have a circle in them. See how the two different styles of 'o' below change how the other letters in the alphabet look.

Look at how other letters take their shape from these two different family styles of 'o'.

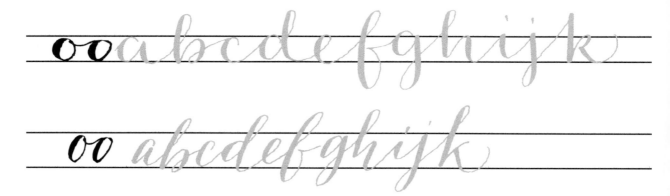

Try and create some of the other letters of the alphabet by going over the 'o' shapes. Notice how the style changes depending on the 'o' shape you are following.

As you write, the ink will dry on your nib even though you're dipping it into the ink. Ink flow will suffer and you won't be able to get crisp, thin lines. To avoid that, dip your nib into your water every couple of minutes and then wipe any stubborn ink on your napkin. Use the pipette to put the odd drop or two of water in your ink or paint if you've been working for a while and it starts to dry out.

Tip
By having the same form throughout an alphabet,
the lettering looks like it belongs together.

Think about the body shape for each project that you do. If you were designing a Halloween invitation, you might choose a narrow body shape for your alphabet. That would give a spiky and sinister look. Compare the two styles below, notice how the rounded lettering doesn't work nearly as well as the narrow for this theme.

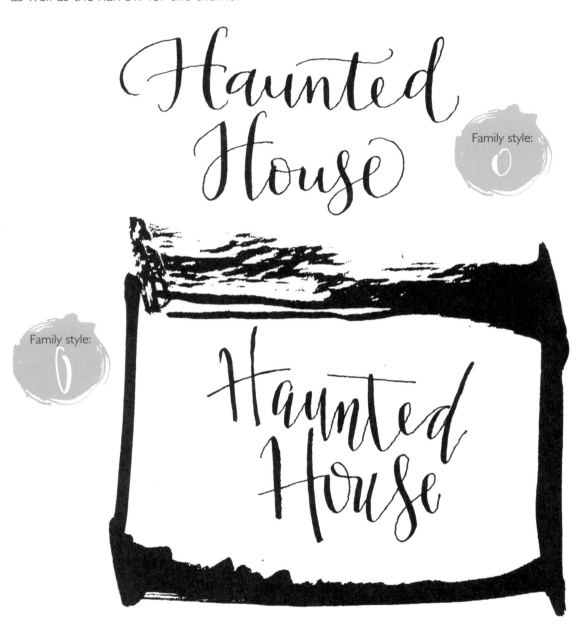

Family style:

Family style:

Tip
The lettering style gives atmosphere to your piece,
even before you read it you can guess what it is about.

Art Card 2

For this second pull-out art card, we need a friendly, open style, so we are using a rounded body shape. Warm up by tracing over the quote below, then work on to the matching pull-out card (art card 2) at the back of this book. You can frame the completed card to decorate your home.

Because of you,
I laugh
a little harder,
cry a little less,
& smile
a lot more

Angles

SECRET 7

The more tilted your angle, the more traditional your calligraphy looks. Modern calligraphy has its roots in Copperplate calligraphy, but for that contemporary style, make your letters stand up straight.

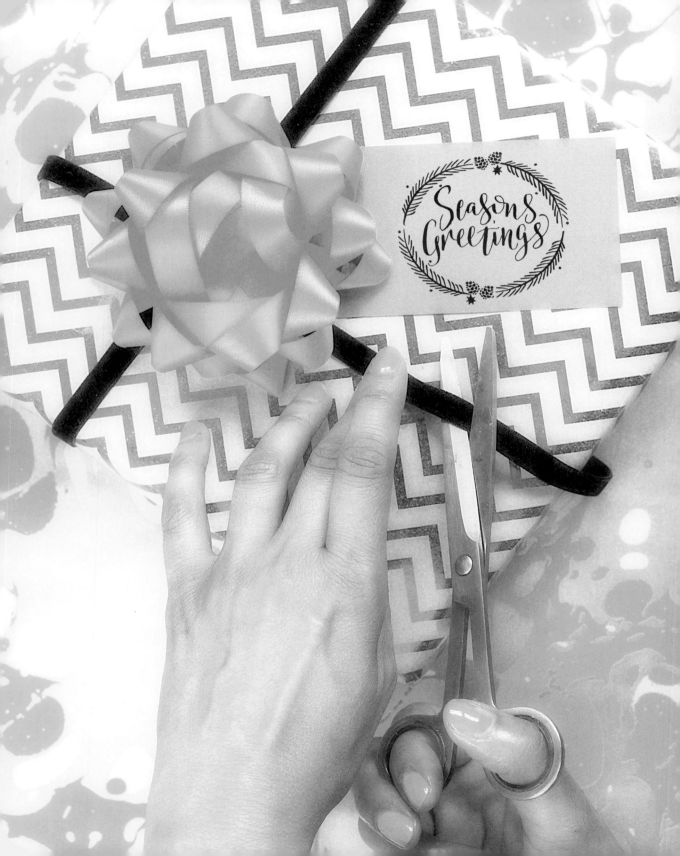

Project 3

Skills:
Angles
Adding illustrations

This fun project will add a touch of style to all your Christmas wrapping. In this project, you will learn about the angle, or 'tilt' of your lettering. The angle you pick makes a huge difference to the look of your work. Once you select the angle you like, keep it the same throughout your whole piece of work. There are exceptions, for example when changing the angle is a feature of a work, but usually a consistent angle is a good rule of thumb.

Can you see the way the thick downstrokes are all at the same angle? A consistent angle, or tilt is what you are aiming for.

merry christmas

merry christmas

Here's the same word with a steeper angle. See how much more formal calligraphy looks when the angle is steeper?

YouTube
Kirsten Burke Calligraphy
Secrets-Angles

Trace over the gray with your pen and aim to get your thick and thin strokes in the same place as the lettering guides.

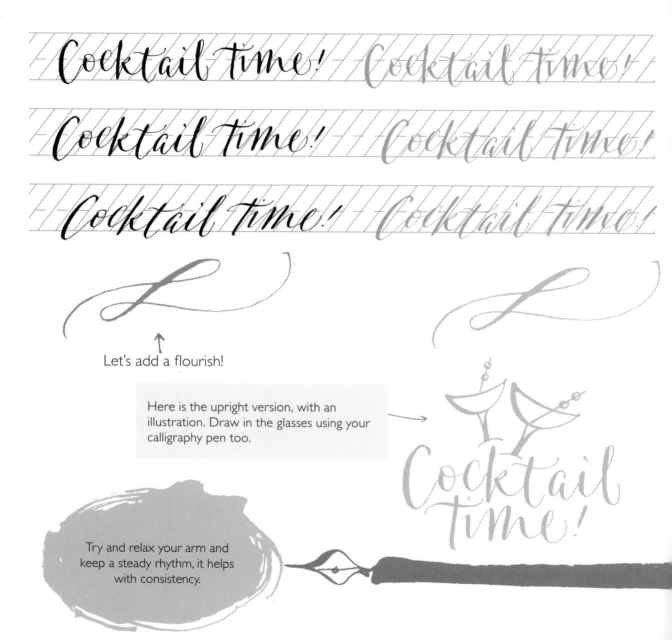

Cocktail time! Cocktail time!

Cocktail Time! Cocktail Time!

Cocktail time! Cocktail time!

↑
Let's add a flourish!

Here is the upright version, with an illustration. Draw in the glasses using your calligraphy pen too.

→

Cocktail Time!

Try and relax your arm and keep a steady rhythm, it helps with consistency.

Tip
If you're picking up fibers on your nib you are possibly pushing too hard. It can also happen when you go back over a stroke that is still wet. Wipe the nib to pull the fibers off gently and carry on with a lighter touch.

In the words below, the angle gets slightly steeper each time. Trace over them and you will probably find an angle that you find more comfortable to write than the others. Make a mental note of it as this is how you begin to develop your own calligraphy style.

Try changing the angle of the words below. They are upright at the moment, so try writing the phrase again with a different tilt for each line below.

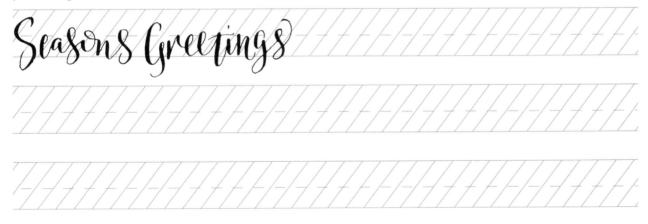

Tip
The angle of your pen always remains the same. While the curves and curls of your calligraphy change direction, your pen position must stay consistent.

Practice Makes Perfect

Here are some festive words, try writing them again at a different angle.

Ascenders and capitals
Waistline
Baseline
X height

Merry Merry Merry

Christmas

Happy

Bright

Santa

Baby

Mistletoe

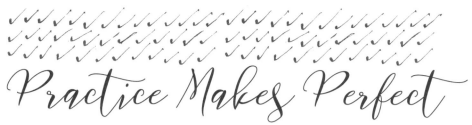

Practice Makes Perfect

Try creating your own seasonal words below.

Art Card 3

Calligraphy looks lovely when it is framed by decoration. Flowers, hearts and flourishes are all popular. For Christmas the options are endless: wreaths, pine cones, mistletoe, holly, snowflakes, bells... these can all look great.
Trace over the gray lines, then complete the gift tags on the matching pull-out card (art card 3).
You can then cut out each tag and use it as a personal touch for your gifts.

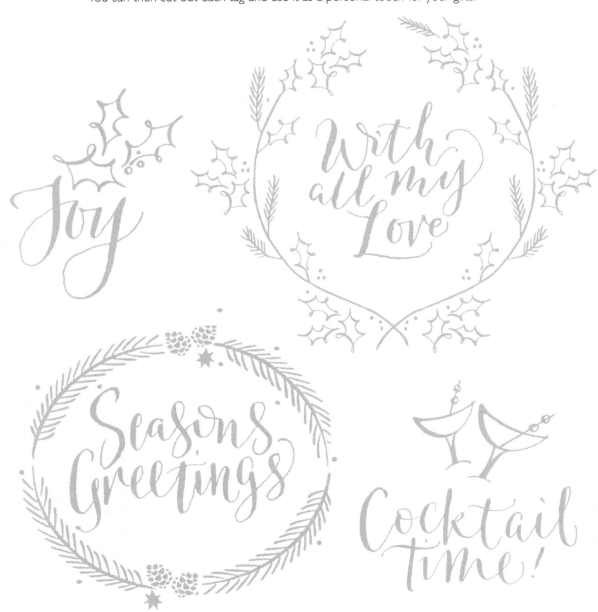

Calligraphy Fonts

SECRET 8

You can use fonts! Using fonts is not cheating. You are starting out on your journey and developing a love of lettering, so use any tools available to help you. There are some amazing calligraphy fonts out there, so use them to help you gain confidence with your own lettering. Look at the shapes of the letters and how they knit together to help you develop your own style. They are great for sizing, spacing and positioning — helping you to see where letters knock together when creating your own artwork.

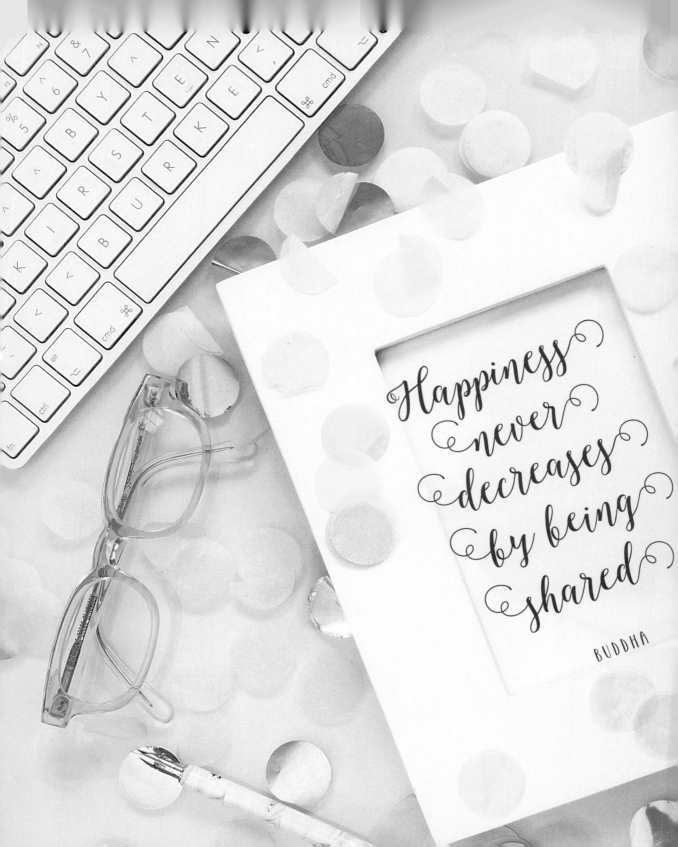

Project 4

Skills:
Fonts
Flourishes

There are so many gorgeous calligraphy fonts available as calligraphy becomes more and more popular. Although they can never take the place of a real person writing, they are a great way to practise when you are beginning to learn calligraphy. For this project, I have used Octavia Font from Creative Market. It is very close to calligraphy and has a lovely rounded style. It also creates flourishes on the entry and exit strokes, which looks so pretty.

Octavia
on Creative Market

Happiness

Bombshell Pro
by Emily Lime

Happiness

Frutilla by Ian Mikraz
at Behance

Happiness

Tip
Take elements from different fonts and incorporate them in your own callligraphy. For example, you might take an 'f' from one font and the 'w' from another.

Search script
or calligraphy fonts on:
myfonts.com
fontsquirrel.com
creativemarket.com
behance.net

Once you've picked a font that you like, use it as a guide. When you first start creating simple layouts they work brilliantly, but as you develop your own style and skills, you will need to leave them behind. For this simple piece, I have used Octavia with all its flourishes.

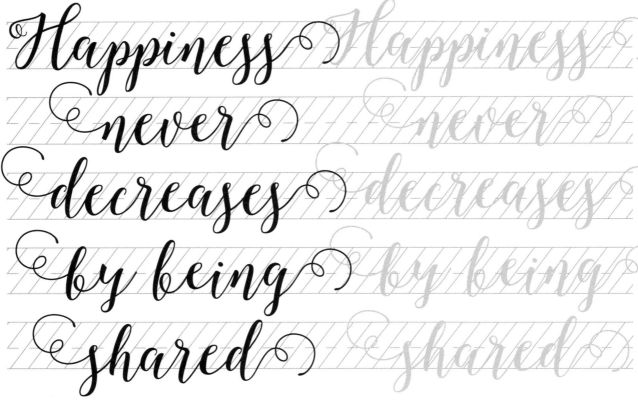

Adding Flourishes

Flourishes can be as simple as adding in extra curves to the end or beginning of letters. They can bring life to a composition, so practice the shape by pencilling it in first to ensure the position works. When inking, don't be tempted to flick, you need to decide where your pen is going and control the flow of the line. If you don't, the flourish will lose its attractive swirl and look spidery.

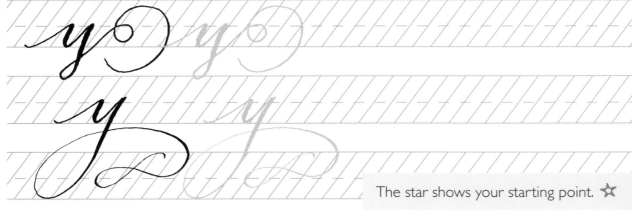

The star shows your starting point. ☆

— 72 —

Remember to keep your pen super light on the paper when adding flourishes, the nib only needs to kiss the paper gently and your arm needs to be relaxed and free. Flourishing comes from the larger movements of the arm, not the wrist, so keep your arm locked and steady.

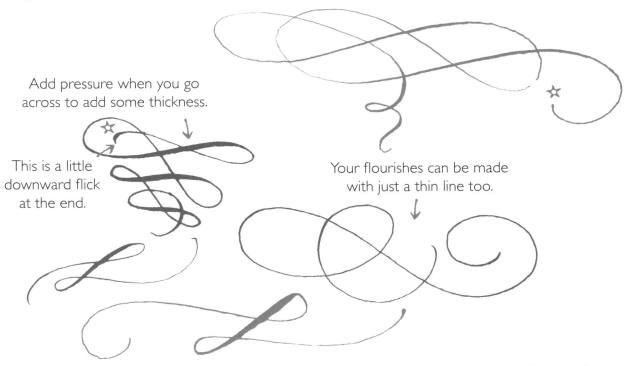

Add pressure when you go across to add some thickness.

This is a little downward flick at the end.

Your flourishes can be made with just a thin line too.

When adding a flourish to a letter, they work best on the first or last letter of a word, or on the ascenders or descenders. I love one on the cross stroke of the 't'.

Take care not to make a word difficult to read because of a flourish that you've added, it's easy to make a shape that reads as a letter. See how the flourishes here could be mistaken for 's' or 'e'.

Tip
Don't be tempted to go quickly, you need to complete a flourish as carefully and as deliberately as you would complete a letter.

Flourishes are a great way to add fun to a piece. They can also work brilliantly to fill a space and balance your work.

Art Card 4

Now that you have learnt about flourishes, practice them on the gray lettering below. When you are ready, complete the lettering on the matching pull-out card (art card 4). Remember to take your time as you ink each letter and its flourish.

Happiness never decreases by being shared

BUDDHA

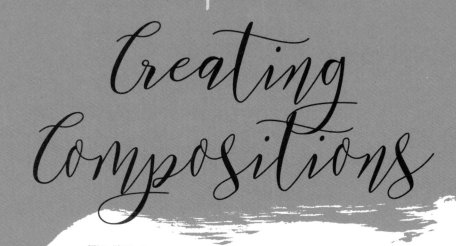

Creating Compositions

SECRET 9

How do professionals always create such perfectly
balanced compositions, with even lines all centred
beautifully? They use layout paper, or better still a
'Lightpad'! What's that? Well, in this next chapter I'll
reveal the professional calligrapher's secret weapon.

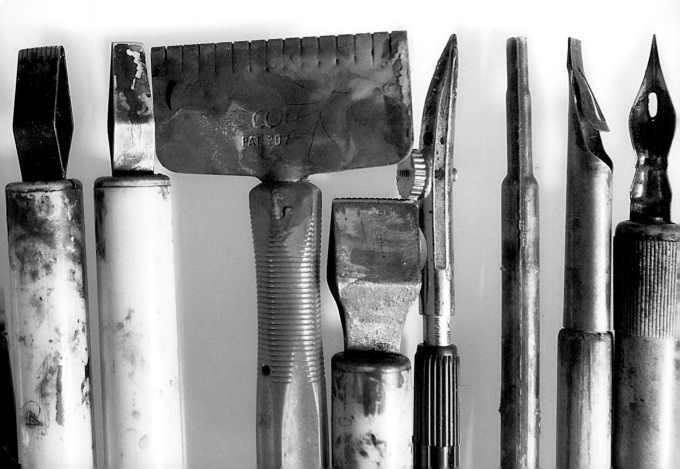

Anyone who never made a mistake never tried anything new

ALBERT EINSTEIN

Project 5

Skills:
Bounce
Composition

So, you are now acquainted with lots of the secrets of modern calligraphy: guidelines, x height and what ascenders and descenders are. You understand body shape (form) and angle. You know all about the correct proportions, the thick and the thin strokes, so what's next? In this project, we are going to shake it all up and play with those rules. We are going to 'bounce' our lettering.

Here is some calligraphy that follows all the rules nicely.

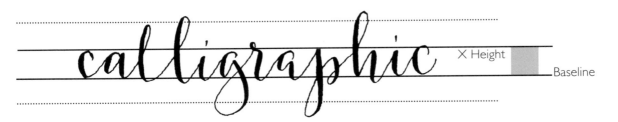

With a bit of 'bounce' we can add energy and a modern style to it. Bounce is a technique that makes the calligraphy jump up and down along the guide lines by reducing the size of some letters and extending the strokes on others. Look below at how an 'o' and an 'e' in bounce lettering are made smaller than the other letters in the word. Parts of the strokes of a letter can be exaggerated, swooping down below the baseline. I have done this here on the 'n' and the 'u'. It can work on 'a' and 'h' and 'p' but when 'bouncing' letters make sure you can still read the them.

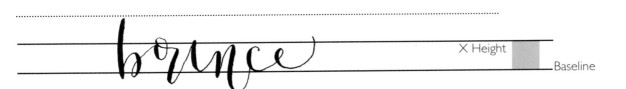

Bouncing your calligraphy is great for creating compositions, as the gaps the bouncing letters make can be filled with the letters on the next line so that the lines become 'knitted' together.

Practice Makes Perfect

Trace over the gray words and then practice writing them.

Anyone Anyone

who never who never

made a made a

mistake mistake

never never

tried tried

anything anything

new new

Play with your letter forms to create something that is truly your own. Sketch your idea out in pencil on the layout paper at the end of the book, then analyze the design to see where you can add flourishes and which words would benefit from standing out. They might be made bigger or use a stronger color. Play with your letter spacing and the ascenders and descenders, so they slot into each other.

Anyone who never made a mistake never tried anything new
ALBERT EINSTEIN

You may want to incorporate a credit for the author, so plan where it will go.

What is the most important word? Make that word bigger or you can emphasise it with some decorations or a flourish or two.

See how the lines here have been tightened by tucking the ascenders and descenders in together and how the letters fit into each other's gaps.

Anyone who never made a mistake never tried anything new

Anyone who never made a mistake never tried anything new

Anyone who never made A MISTAKE never tried anything new
ALBERT EINSTEIN

Make a shape with the words. Draw the shape in pencil first, then work out the size your calligraphy needs to be to fit into it.

Mix up the styles. Capitals look great alongside modern calligraphy; just don't go for curly capitals. Keep them simple if you are writing a whole word with them.

YouTube
Kirsten Burke Calligraphy
Secrets-Bounce

Lightpad

This is your secret weapon.
Whenever I can, I use a lightpad. This is a small, flat LED screen with dimmable brightness that you can use for tracing. It's great for calligraphy and any other artwork. LED lighting means that lightpads have only recently become small enough (A4 or bigger) and affordable enough (approx $26) for any calligrapher, artist or designer to own – every home and calligrapher should have one!

With a lightpad you will never again reach the end of a piece and run out of room for the last few words. I work in pencil to sketch out my ideas in rough, I then take another piece of paper and put it on top of my sketch and trace over it again with pencil as I can see the original shining through. By doing this, I can play around with my final design – making the letters bigger or smaller, making sure the words are in the center. If you do have a gap that you just can't fill, put in a flourish or a little illustration. It really is an invaluable tool!

Practice Makes Perfect

Try creating your own 'bouncing' words below.

Tip

Play around with the rules for a modern twist but always have an eye
on the lettering and phrasing. You want your work to be legible.

Art Card 5

Enjoy the bouncing lettering of this next art card. Warm up by tracing over the phrase below, then work on to the matching pull-out card (art card 5) at the back of the book.

Anyone who never made a mistake never tried anything new

ALBERT EINSTEIN

Dip & Wash

SECRET 10

You can dip straight from one color to the next without washing your nib and you will get stunning blends. When you dip into the second color there will only be a tiny amount of the first ink left on your nib. When it's mixed with what's already there you won't notice the difference, so have fun with it.

You can never cross the ocean until you have the courage to lose sight of the shore

CHRISTOPHER COLUMBUS

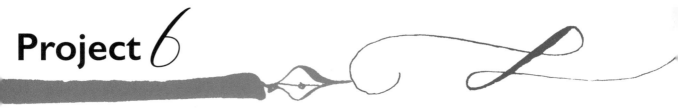

Project 6

Skills:
Dipping
Making washes

Calligraphy is beautiful in black, but bringing blues in for a phrase about the sea, or pink when you are decorating a little girl's bedroom can really bring a piece to life and best of all, it is very simple to do.

Dipping

I am going to teach you how to blend colors together so that your lettering glides from one color to another. See below. Take two pots of colored ink, think about the color they make if you mix them as that is what will happen within your callligraphy. Dip into the first pot of ink and once that ink runs out, dip into the contrasting color. Go straight in, a drop or two of the first color may go into the second pot, so if you cannot bear that, touch your nib on your napkin before you swap. The blend is better if you don't mind that tiny bit of mixing though. Now continue with your callligraphy, starting with the new color from where you left off. The colors should run into each other, which looks really gorgeous.

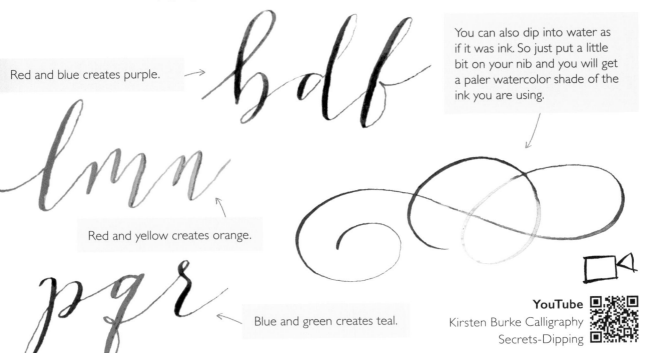

Red and blue creates purple. →

You can also dip into water as if it was ink. So just put a little bit on your nib and you will get a paler watercolor shade of the ink you are using.

Red and yellow creates orange.

Blue and green creates teal.

YouTube
Kirsten Burke Calligraphy
Secrets-Dipping

Practice Makes Perfect

Practice dipping your colored inks here.

Making Washes

Creating washes for your lettering to go over is great fun to do. Just remember that less is more. If you make the wash color too dark, your calligraphy can't be seen, so use the ink sparingly in your wash. Start by wetting the area you want to be colored with water using a clean paintbrush, next add a couple of drops of colored ink on to it with a pipette or the brush. You can use a couple of different colors to create rainbow effects.

You can create an ombre effect by rinsing your brush out completely, and applying another color, blending it while the first is still wet.

Alternatively, water down strong inks by painting a stroke at the top of the area you are working on. Dip your brush into water and paint it to dilute the ink. Keep going with this until the whole area is filled.

Once the wash has dried, you can work over it with your calligraphy. If you have a lightpad, use it in the same way. You should be able to see through the color wash and so be able to follow your pencil guides.

YouTube
Kirsten Burke Calligraphy
Secrets-Washes

Art Card 6

Try filling in the letters below with black ink, then turn to the back of the book to complete the matching pull-out card (art card 6).

You can never cross the ocean until you have the courage to lose sight of the shore

CHRISTOPHER COLUMBUS

Adding Some Bling

SECRET 11

This secret is a special one that I wanted to share with you. The secret to creating artworks with stunning metallics is to use Finetec paints. Creating calligraphy in silver and gold looks gorgeous on dark card, so once you've got the hang of it you'll be 'blinging' every piece you do!

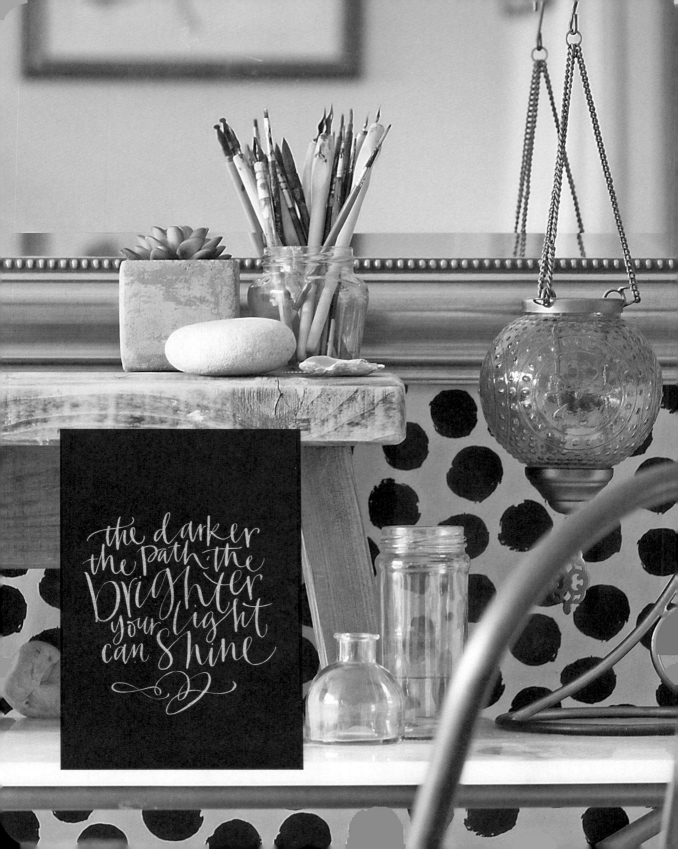

Project *f*

Skills:
Writing with Finetec metallic paint
Layout tips

Everybody loves a bit of bling, but traditionally using metallics has been a somewhat hit and miss affair for calligraphers. Metallic inks separate unless they are stirred with a magnetic stirrer, or are constantly shaken – not very user friendly.

Not any more! A wonderful product called 'Finetec' has come along to solve every calligrapher's troubles. Finetec make 2 different metallic paint palettes. Finetec Golds has five shades of gold and one silver. Finetec Pearl Colors palette has red, copper, yellow, green and two shades of silver. These palettes are fairly expensive, but they last for ages and are worth every penny. To be on the safe side, you can buy one single block of color individually to see if you like them before investing in a whole set.

Each solid block of metallic paint can be transformed into a liquid consistency by adding a few drops of water. Use a pipette to control the amount you add, then mix vigorously with a small paintbrush. At first, the water will sit on top of the paint so keep adding drops of water until the paste thins out to a liquid – you want to make it similar to the consistency of the inks you have been using (a bit like single cream). Be patient. The consistency of the paint is the key to success. You can enhance your calligraphy further by using the metallic paint to make decorative borders or pretty patterns.

Once you have the correct consistency, use your brush to load the nib with paint. Fill your brush up with the paint and then drag it across the underside (back) of the nib to coat it with the paint. Now you are ready to go!

When you have finished, the water simply evaporates leaving the solid block of paint behind ready for you to use again.

Still not sure? You can see it in action in this video.

YouTube
Kirsten Burke Calligraphy
Secrets-Finetec

Practice Makes Perfect

Practice dipping your metallics here.

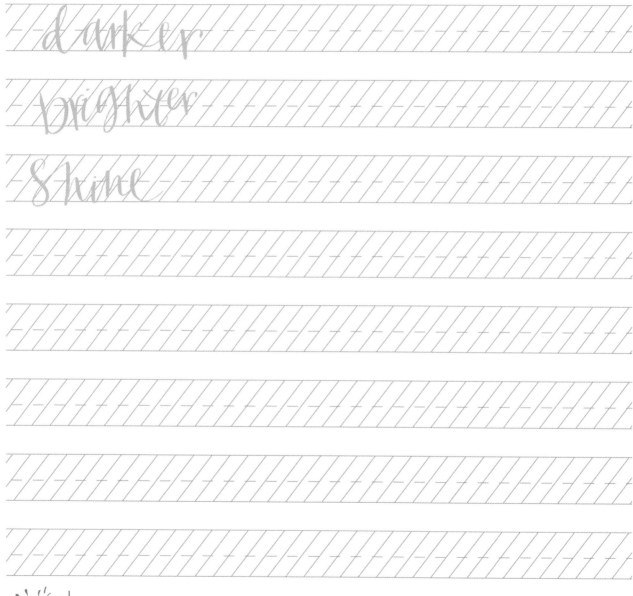

darker

brighter

Shine

Tip
Keep adding water to your Finetec palette so it doesn't dry up while you work. Unlike ink, it will dry out and then won't flow from your nib. Keep adding drops of water to keep it fluid.

Layout Tips

The quote below will work really well in gold on a dark background because the quote's meaning is all about shining through when times are tough.

Look at how bounce lettering is used to create the composition. Start any composition by stacking the words one line above the next, with two or three words per line. Writing the words out in this way allows you to see where ascenders or descenders knock into each other. You will also start to see where you need to play with the length of the lines to make the whole piece into a nice shape.

the darker the path, the brighter your light can shine

Here the first line is too long, the composition looks top heavy.

Here the letters knock into each other, and the last line being much shorter isn't very attractive.

the darker the path the brighter your light can shine

the darker the path, the brighter your light can shine

Play with proportions to make lettering that's quirky and full of character. By making some words larger, you can balance the piece.

It's a good idea to sketch your ideas out in pencil before you labor over your letter forms. That way you can disregard layouts that aren't working quickly and without having spent hours on them. Once you've found a layout that works, that's the time to pick up your nib and start to refine your lettering.

Remember when you work on dark card at home you can't see through to any template or pencil guides you may have made using layout paper or a lightpad. So work out your design in rough first, then with a pencil lightly copy, or sketch it on to the dark card. Next, trace over your pencil guide with the metallic paints, then rub out the pencil marks once the paint has dried.

Art Card 7

For your final art card, practice writing over the phrase below, then use gold Finetec to complete the matching pull-out card (art card 7) at the back of the book.

the darker the path the brighter your light can shine

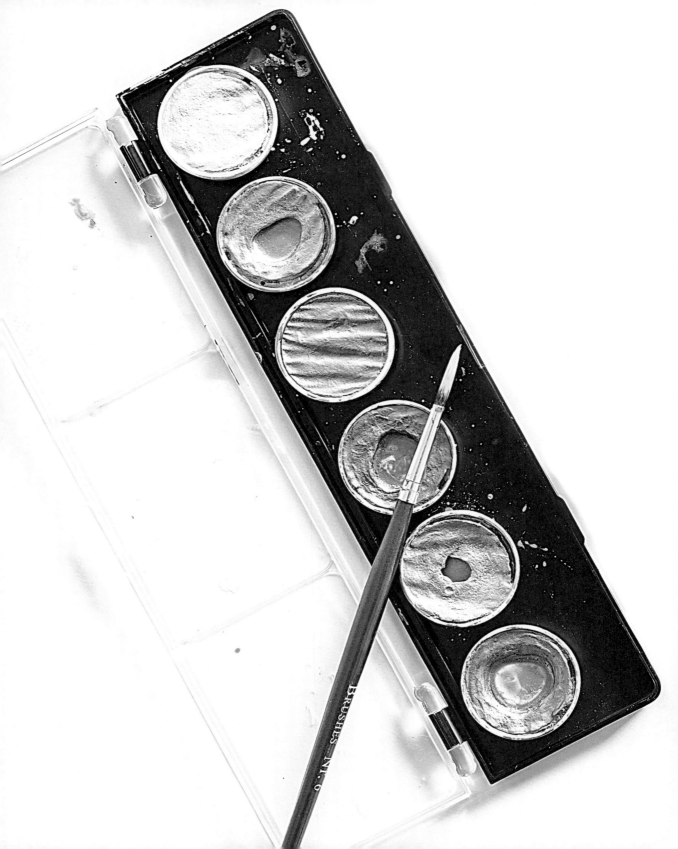

Reminder!
Go back to page 28, and see
how much your calligraphy has
improved!

To Sum Up!

SECRET 12

Rules and proportions are important to understand, but the final secret to great modern calligraphy is to throw away those rules and play with them to make lettering that's quirky and full of character. Let your personality shine through. Decide what is going to be the focus of your message, then take a blank page and sketch boldly in pencil. Don't overthink it — see what happens. Your piece will come to life and then use the skills and secrets you have learned to balance and perfect it.

Practice Makes Perfect

Practice Makes Perfect

Practice Makes Perfect

Practice Makes Perfect

Practice Makes Perfect

Practice Makes Perfect

Workshops

Learning calligraphy

is so rewarding; not only can you turn the words you love into your own pieces of artwork to hang around your home, but while you work you are completely focused. In this age of mindfulness, we all know what a benefit that is to our health. All the students at our workshops comment on how engrossed they become in their work. When they are concentrating on the shape of the letter form, making the pen work and remembering to spell the words they are writing correctly, worrying about anything else is impossible!

We have worked hard to clearly explain the tricks to help get your pen working and the ink flowing so that your calligraphy looks great. We wanted this to be as near as we could get to the workshops that we teach in our studios and all over the country. The big difference is that when I teach a workshop, I'm able to show students exactly where to make adjustments that make all the difference to picking it up quickly. That's why we've created the YouTube video tutorials that are labelled throughout the book, so that you can watch how to do some of the skills that might be hard to grasp.

Workshops are becoming more and more popular and are popping up all over the country. If you can get to a workshop near you, I can't recommend it enough. Bring the family and plan a weekend around your calligraphy workshop! Learning together means you can chat about your lettering and get inspiration from each other. Some of my students have set up evening meets, where they get together to practice their lettering, so it can be a great way of making new friends.

With Pinterest and Etsy now full of modern calligraphy, there's no shortage of inspiration online too. New, fresh calligraphy styles have given this ancient craft a new lease of life.

Why not follow us on social media where we post fun projects, inspiring work and show you what a calligrapher does all day.

YouTube: Kirsten Burke Calligraphy
Instagram: kirstenburkedesigns
Twitter: kirstenburkeart
Facebook: kirstenburkedesign
Pinterest: Kirsten Burke Contemporary Calligraphy

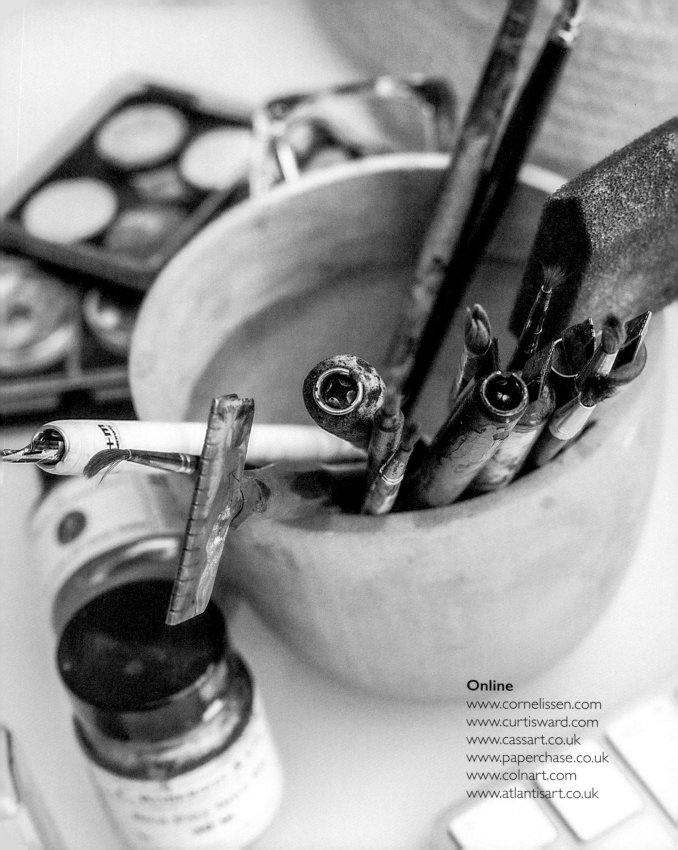

Online
www.cornelissen.com
www.curtisward.com
www.cassart.co.uk
www.paperchase.co.uk
www.colnart.com
www.atlantisart.co.uk

Suppliers

Modern calligraphy

is having a complete renaissance at the moment and as such everything you need can be easily obtained from most major high street and online retailers.

You can often end up paying a small fortune when you are starting out as it is often difficult to know exactly what nibs, inks and tools to buy, so I've put together an 'essentials kit' for this book, which gives you everything you need. You can buy it online on **Amazon** or **Etsy** if you search via Kirsten Burke Calligraphy, or on my own website **www.kirstenburke.co.uk**. I've also created starter kits, which make fantastic gifts and will hopefully develop a lifelong interest for hand lettering in both adults and children.

Places to Shop

Hobby Lobby Arts & Craft Stores – there are hundreds of Hobby Lobby stores across the US. Based in Oklahoma City, their 750 stores enable customers to get creative through many kinds of craft. Here you can find the nibs we recommend in this book, plus ink, paper and everything else you need for your lettering.

John Neal Bookseller produces the only industry magazine dedicated to calligraphy. The Letter Arts Review has featured lots of my work over the years, and is full of inspiration for any aspiring calligrapher. You can also buy the nibs, paint and ink you need from their website too, www.johnnealbooks.com

Other stockists of the nibs we recommend are:
Michaels Stores, www.michaels.com, order online or instore.
Paper and Ink Arts, buy at their Nashville store, or order online at www.paperinkarts.com.
Dick Blick, order online at www.dickblick.com.

Don't forget that you may have a **local art shop**. Wherever possible, we try and support ours, as they are mostly independent people who love art and will happily give advice on what to use and try their best to help you find what you need. As calligraphy is getting more popular, lots of them stock nibs, inks and paper.

If you are ever in the UK…

Cornelissens is a legendary art shop in Bloomsbury, London, which is more than 150 years old. If you're looking for high-end, hard- to-find art materials, this is the place to go. It's like stepping back in time; a Harry Potter-like treasure trove full of amazing wooden display cabinets with apothecary-style glass jars full of brightly coloured pigments.

Atlantis is the largest art materials store in the UK, based in Old Street, London. They are an icon of London's East End, at the heart of the largest concentration of artists in the world.

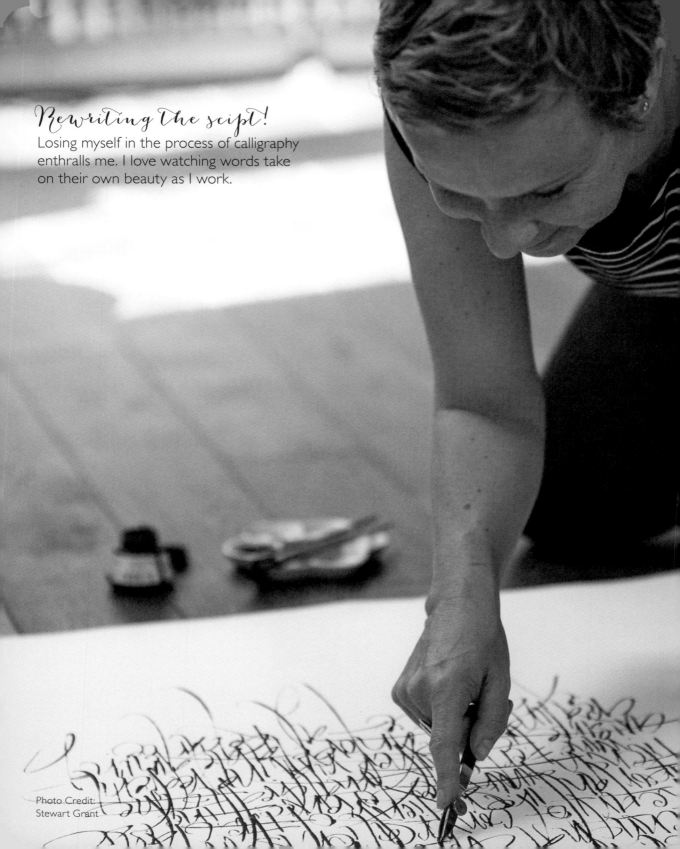

Rewriting the scipt!

Losing myself in the process of calligraphy enthralls me. I love watching words take on their own beauty as I work.

Photo Credit:
Stewart Grant

Our Story

The shape of words has fascinated me since

I was a girl, growing up in South London. I loved books, but I was a slow reader and struggled with my spelling. When it came to writing, I had to concentrate hard on the longer words. Maybe that's what focused my mind on the individual letters. I realized there was beauty in the visual effect of words and it wasn't long before I could stylize my writing to mimic others that I liked.

Styling your handwriting takes a certain skill and I wanted to develop mine into an art form. When I left school, I decided to do a degree in graphics and learn all about lettering design and typography. I loved the first year, then came back for my second year after the summer break and all the manual techniques we'd been taught had been replaced by computers. Without the hands-on element, graphics didn't interest me, so I managed to persuade my tutors to let me complete my degree using hand lettering.

Having completed my BA, I enrolled in a post grad course learning to master the skill of traditional calligraphy with a broad edged nib, illuminated lettering, gilding and bookbinding. I spent a year learning to create the most exquisitely perfect lettering, every letter, every angle identical, but what I loved most was making bold vibrant pieces that looked at the meaning of the words and turned them into art – making pictures out of the words.

My first job when I left was teaching calligraphy in West London part-time to adults, but then my school friend Jill asked me to come and work for her as she was running a new style of wine bar called All Bar One in the City of London. They had massive blackboards with the menus written on in white chalk – a whole new look for pub menus. When they realised I was a calligrapher, I ended up chalking up the menu boards for all their bars in central London and designing all their internal signage.

Spotting an opportunity, Jill put on an exhibition of my work in one of the bars. We hung 14 huge, framed pieces on chains from the ceiling, with quotes on all about food and drink, so I used food coloring as ink and created them all in a very modern lettering style, almost like graffiti. The exhibition was such a success, we got sponsored to tour it around the country in all the bars.

At the end of the tour, in the last bar I got my first big commission, to create a 42-foot timeline for the iconic Globe Theatre, Bankside, depicting Shakespeare's life and work. This really kickstarted our business, so in 1997, Jill and I set up Kirsten Burke Calligraphy from a studio in Deptford.

For many years, we worked on private commissions and public artworks, and exhibited in galleries both in the UK and the US.
We also started our own range of greetings cards, which were ground-breaking at the time as they featured no illustrations, only text. 10 million cards later, they are still available on the high street today, 20 years on. Next, we decided to put our modern calligraphy on to wedding stationery, so set up and ran 'Mandalay Wedding Stationery' for 10 years, winning Best Wedding Stationery Company in the UK five times, and helping over 30,000 brides!

Nowadays, computers have made it easier for people to design their own stationery, but at the same time, the digital age has given rise to a greater awareness about design and much easier access to amazing ideas and styles. There's a renaissance in calligraphy right now, due in part to the re-emergence of the Copperplate nib. In the past, it was used for very formal lettering, but lately it has been re-employed to create a chic, informal style of work – which we now recognise as modern calligraphy.

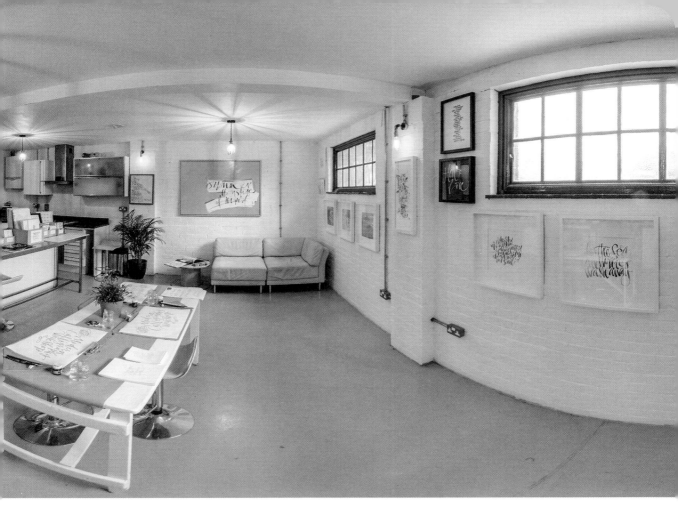

In 2012, Jill and I relocated our business to the south coast of England and moved down from London with our families. We still undertake commissions for big clients, but we also run workshops from our fabulous studio in the heart of the Sussex countryside. It's wonderful to be able to share my craft through our workshops, and now with you, through this book. In this increasingly stressful digital world, I feel so lucky to be able to offer people an escape from it all, as they learn a centuries old skill in a 21st century modern way.

Photo Credit: Stewart Grant

Acknowledgements

This book wouldn't have been possible without the help and support of all the people around us. So we would like to take this opportunity to say a massive thank you to everyone that helped with this book, we couldn't have done this without you!

To Gemma, Nia and the team from Studio Press Books who've been fantastic to work with. They shared the same dream, to create a fun and interactive book that really focuses on the basics, so you are able to develop your own love of lettering and eager to learn more.

To Dave Breen who dropped everything to come to our rescue and sort out the graphics. To Rebecca and Jason who made it look beautiful. To Amanda and Fiona who played with our words until they made sense. To the people who came along to our workshops and allowed us to take photos and videos of them to include in this book.

Thank you to Ian Mikraz whose font, Frutilla, is used for the chapter titles throughout the book. To all our friends and family, who covered for us, looking after our kids, so that we could find the time to write this first book, especially our kids and husbands.

To all you budding calligraphers who bought this book – we hope we have helped you fall even more in love with lettering.
Love from,
Kirsten and Jill

The Studio

Concept & Text: Kirsten Burke and Jill Hembling
Design & Illustrations: Kirsten Burke
Photography: Jason Hedges
Styling: Rebecca Sharrod
Models: Karie Wright, Lily Mahoney & Freya Condron

Winsor & Newton™ is a trademark of ColArt.
Leonardt is a brand of the Manuscript Pen Company Ltd.
Brause is a brand of Exacompta Clairfontaine.
Finetec is a brand of Finetec GmbH.
All product and company names, images, brands and trademarks are the property of their respective owners, which are in no way associated or affiliated with Studio Press, or Jill Hembling and Kirsten Burke. Product and company names, websites and images are used solely for the purpose of identifying the specific products that are used. Use of these names and images does not imply any responsibility, cooperation or endorsement.

would you
like an
adventure
now
or would
you like
your
tea first
?

PETER , PAN

Because of you,
I laugh
a little harder,
cry a little less,
& smile
a lot more

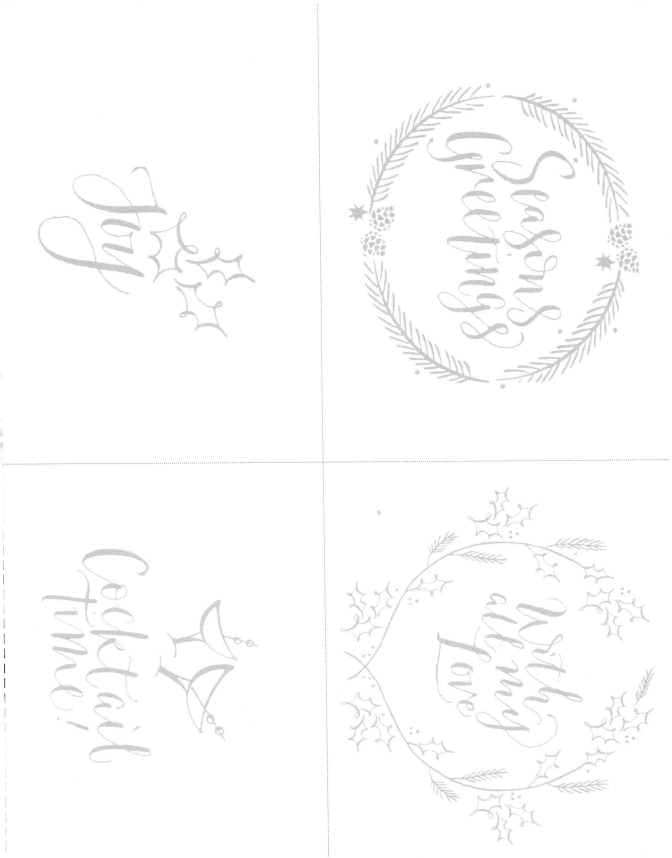

*Happiness
never
decreases
by being
shared*

BUDDHA

Anyone who has never made a mistake never tried anything new

ALBERT EINSTEIN

You can never cross the ocean until you have the courage to lose sight of the shore

CHRISTOPHER COLUMBUS

the darker
the Path. the
brighter
your light
can Shine

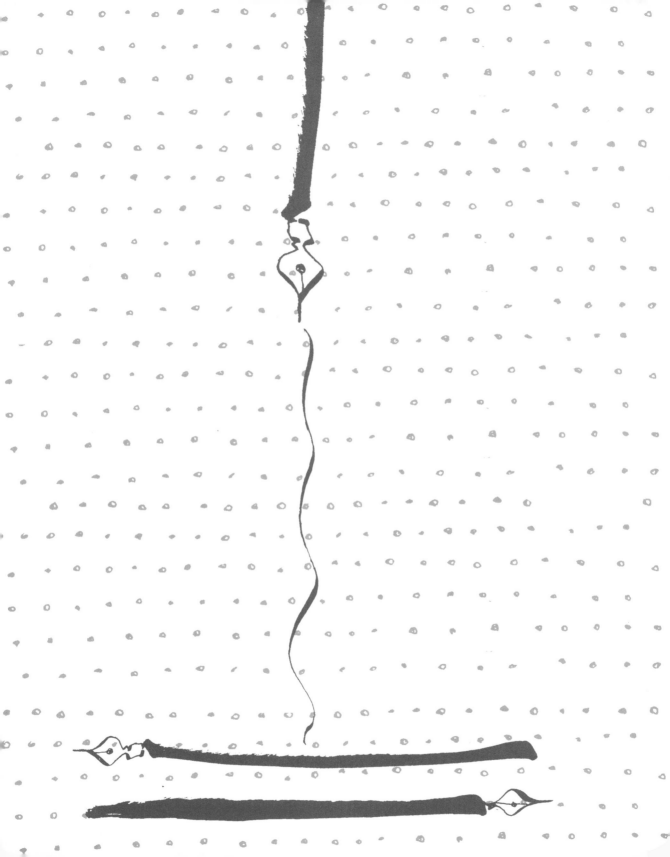